Grand Central Publishing
Hachette Book Group
1290 Avenue of the Americas
New York, NY 10104

www.HachetteBookGroup.com

Printed in the United States of America

WW

Published in Great Britain by Sphere, an imprint of Little, Brown Book Group

First American Edition: October 2015
10 9 8 7 6 5 4 3 2

Grand Central Publishing is a division of Hachette Book Group, Inc.
The Grand Central Publishing name and logo is a trademark of Hachette Book Group, Inc.

The Hachette Speakers Bureau provides a wide range of authors for speaking events. To find out more, go to www.hachettespeakersbureau.com or call (866) 376-6591.

The publisher is not responsible for websites (or their content) that are not owned by the publisher.

ISBN: 978-1-4555-3876-8

The Candy Crush Adult Coloring Book

Creatively Color the Candy Kingdom

GRAND CENTRAL
PUBLISHING

NEW YORK BOSTON

Set in the magical world of the Candy Kingdom, it is here where we are introduced to its inhabitants Tiffi and Mr. Toffee, who owns the Candy Store in Candy Town.

Magic!

The delicious Candy Kingdom features divine landscapes, sweet patterns and the delectable super-sweet candies.

All you need are pens, pencils and a bit of imagination to bring the magical world of Candy Crush Saga to life!

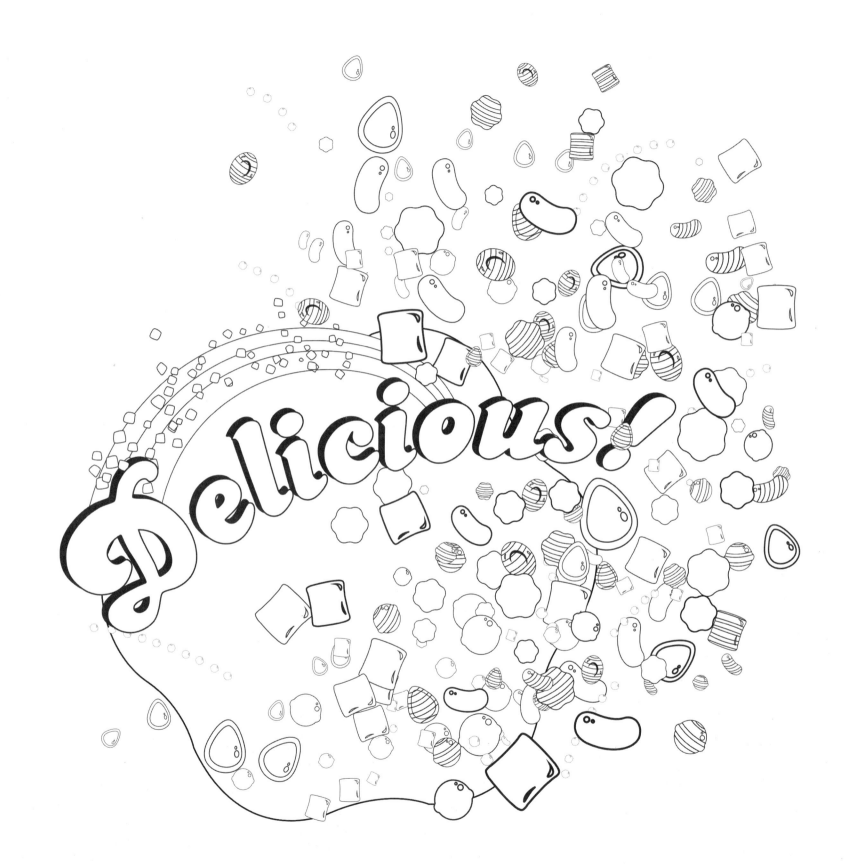

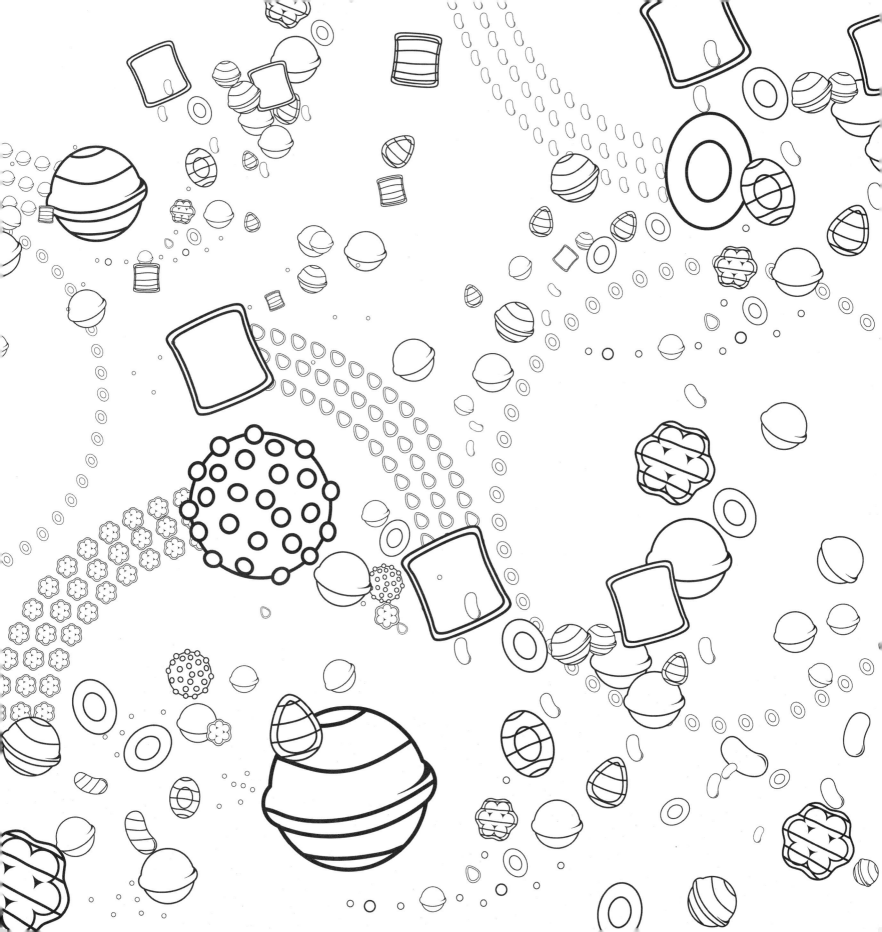

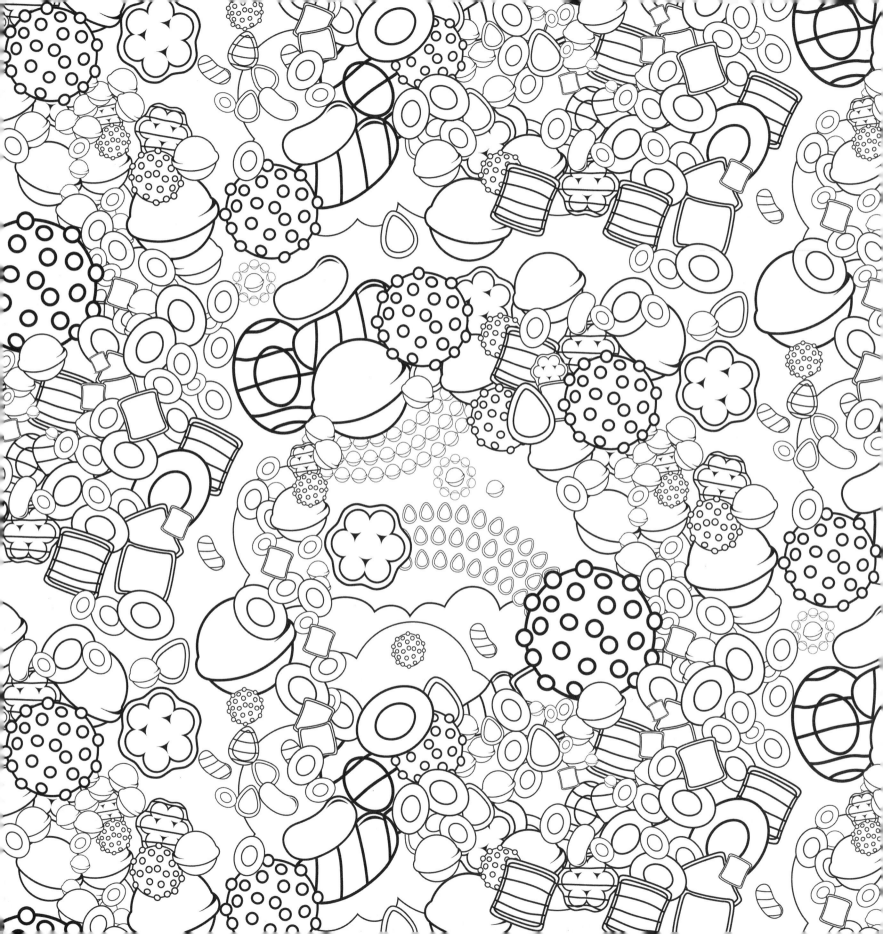

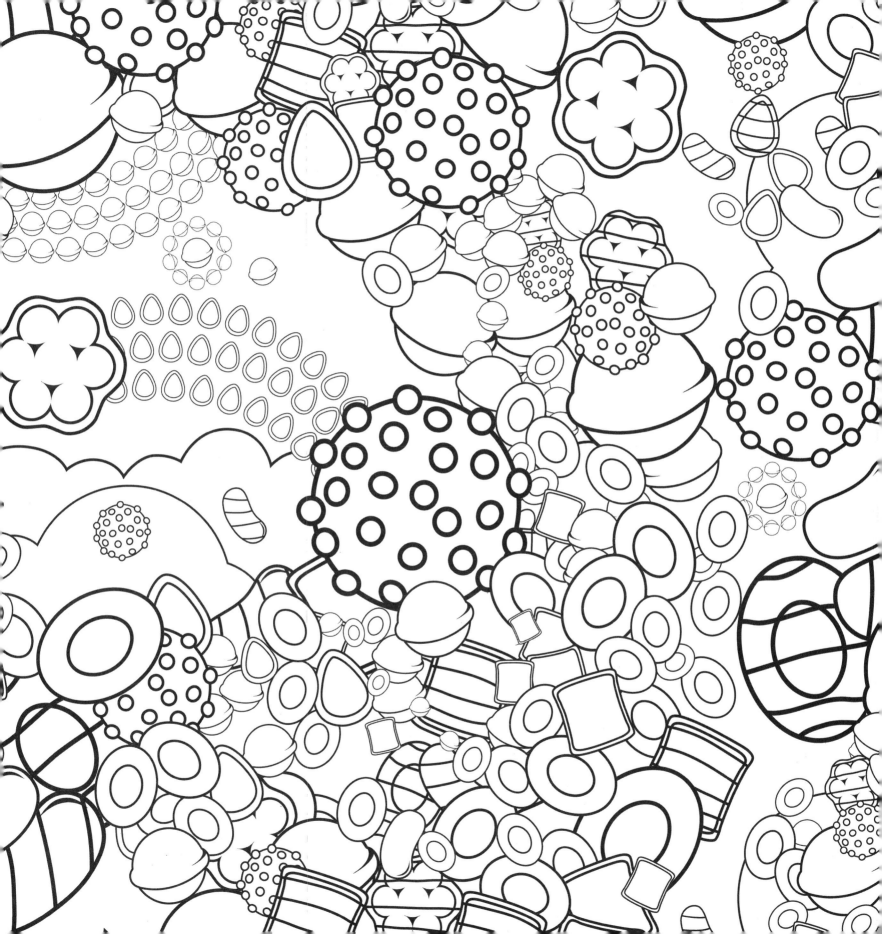

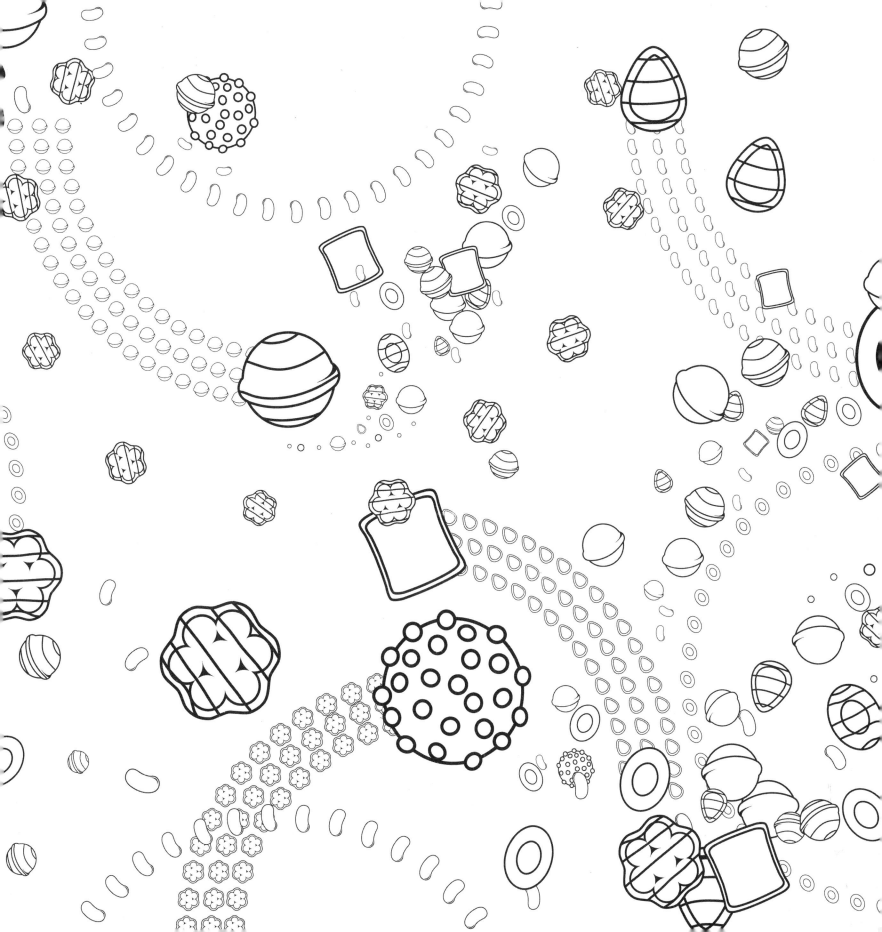

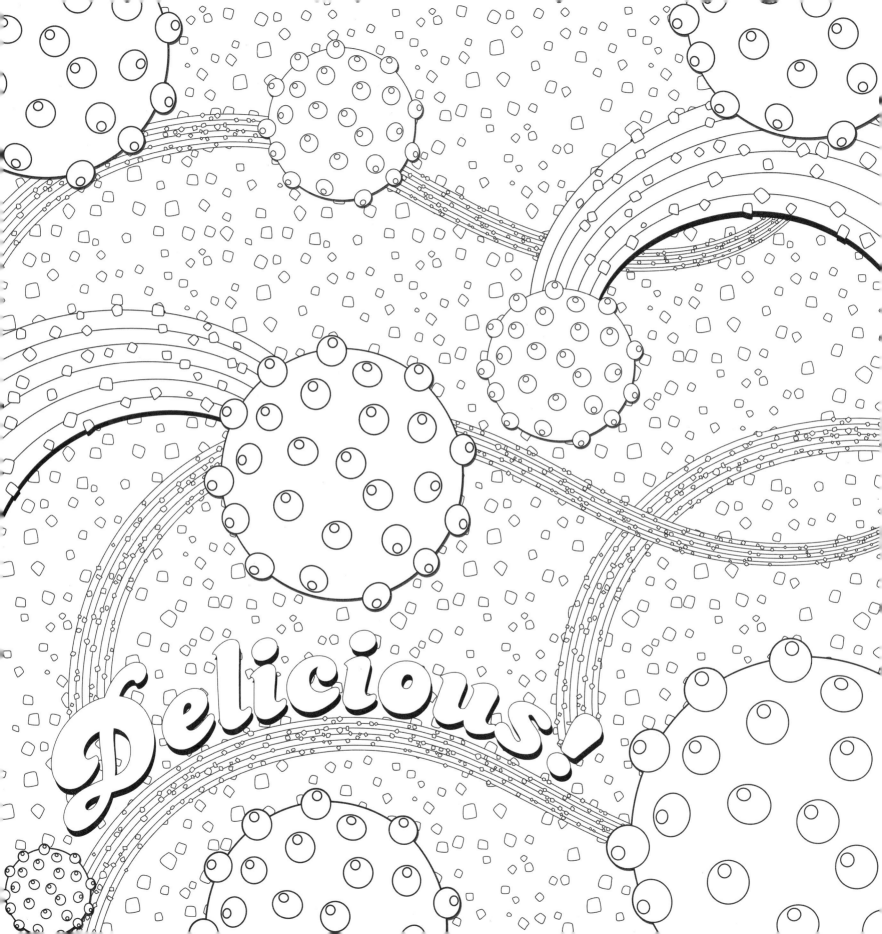

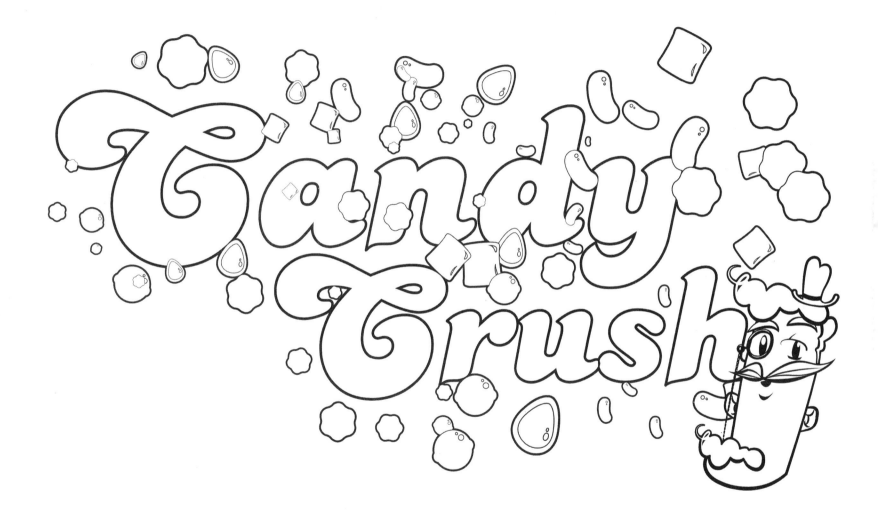

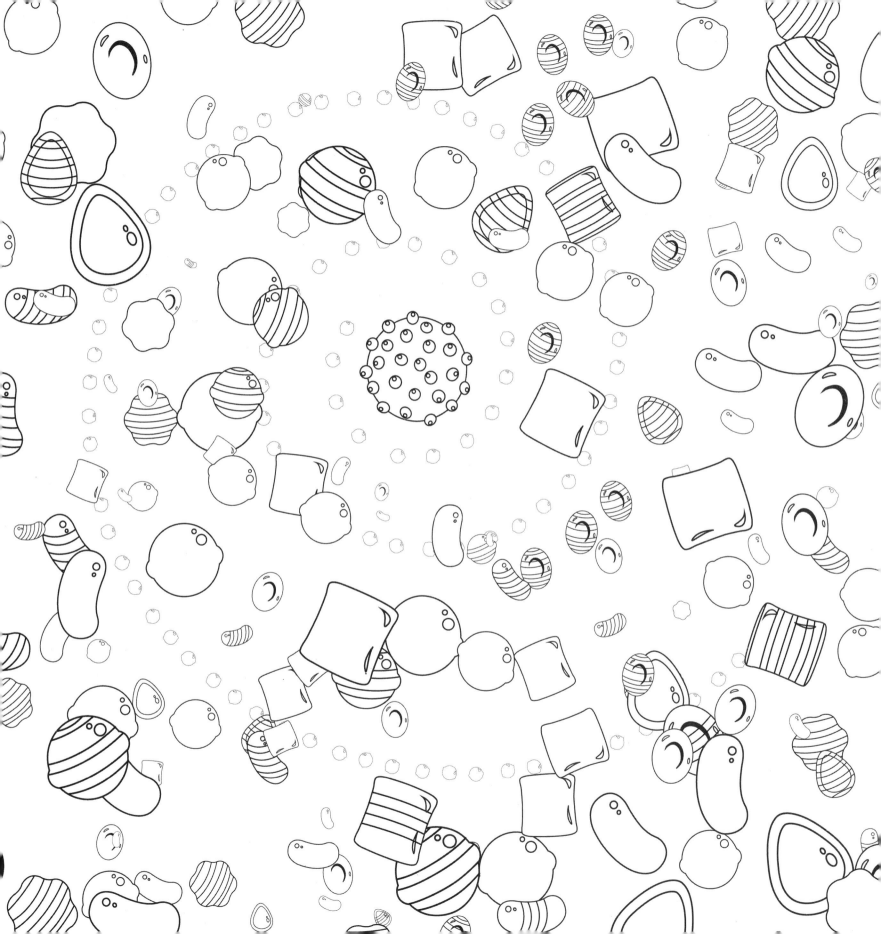

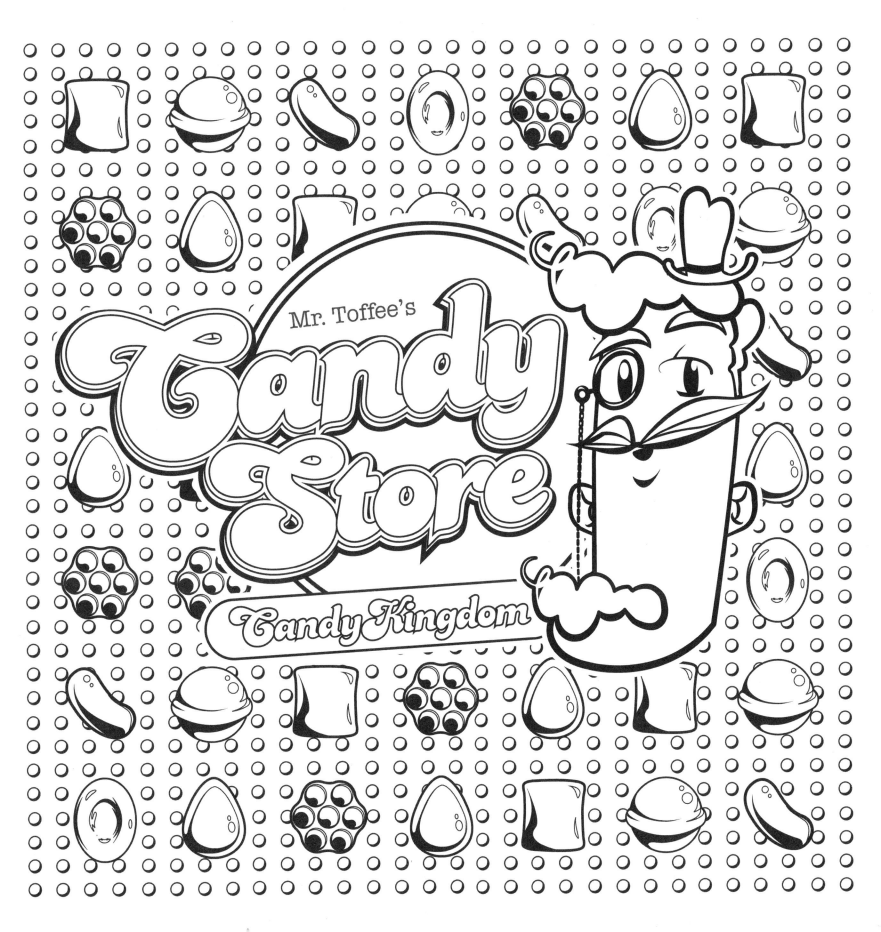

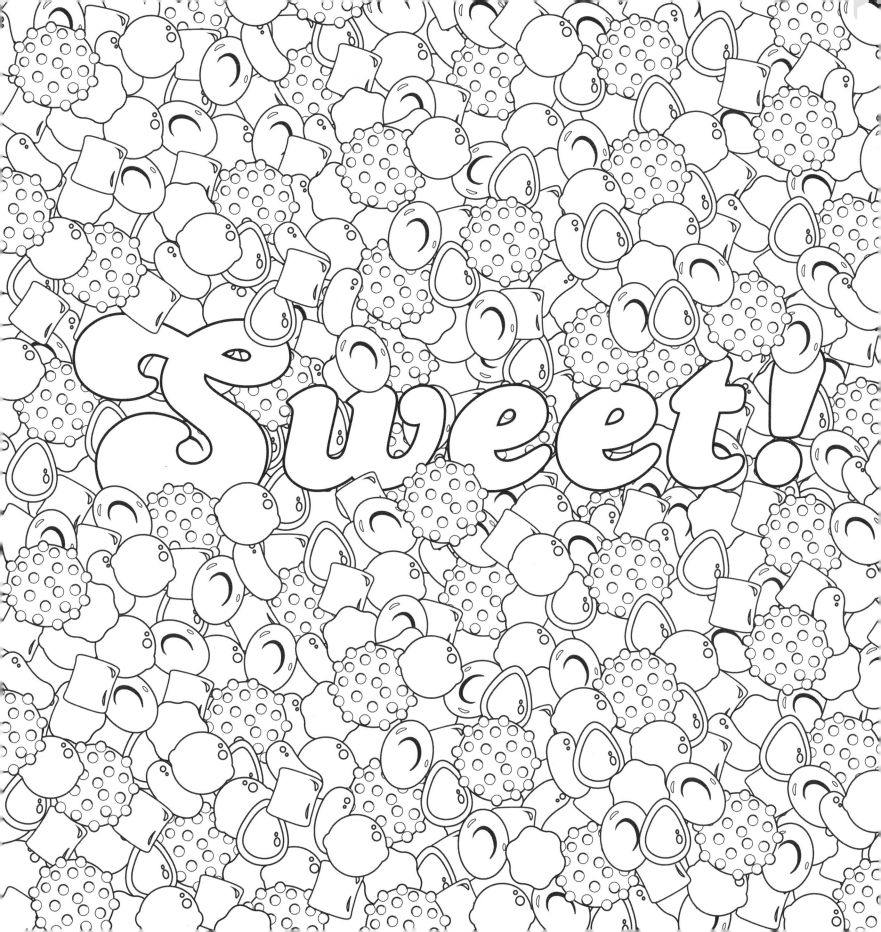

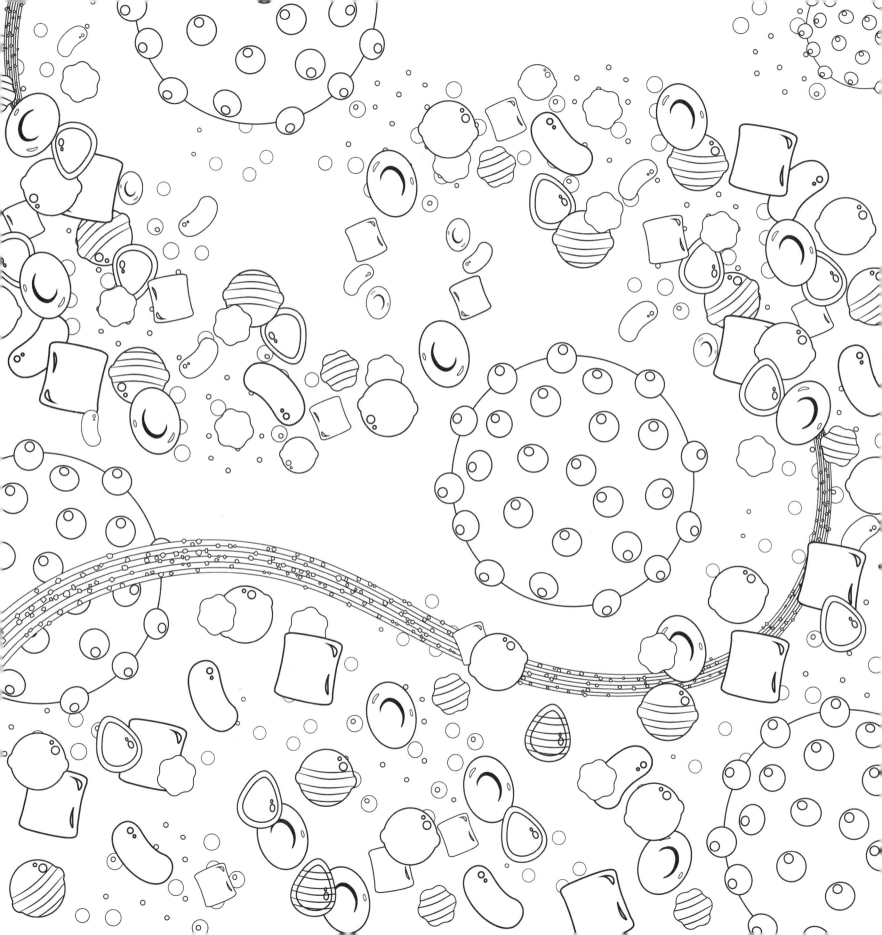

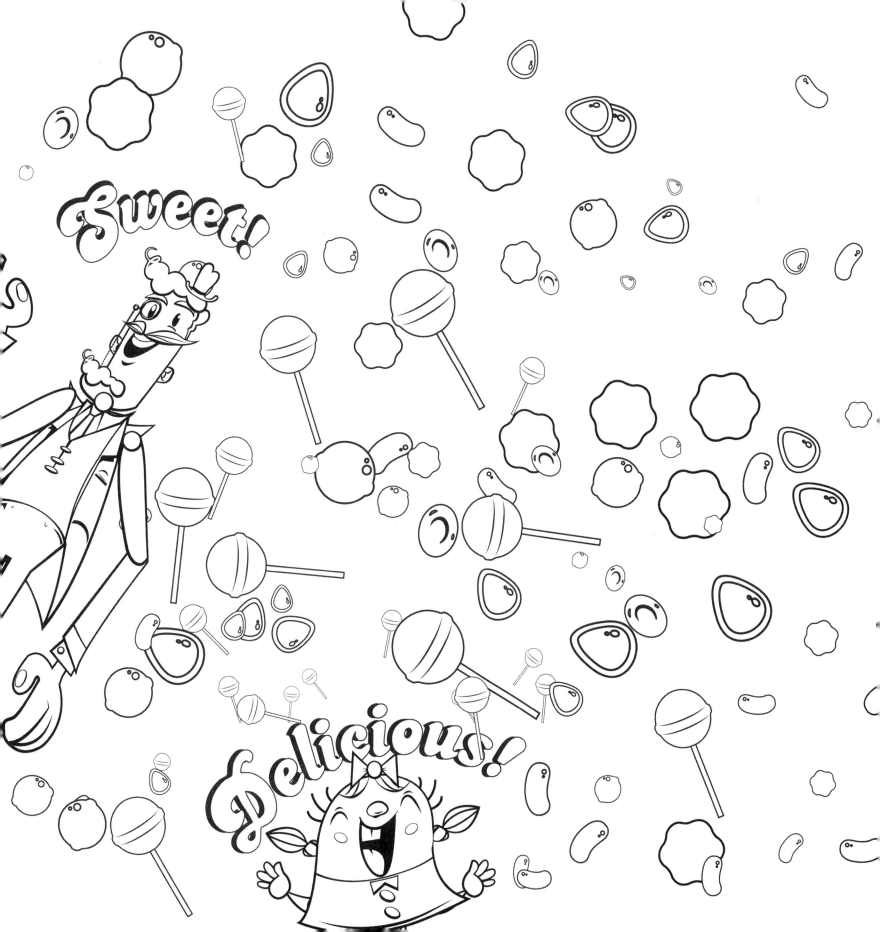

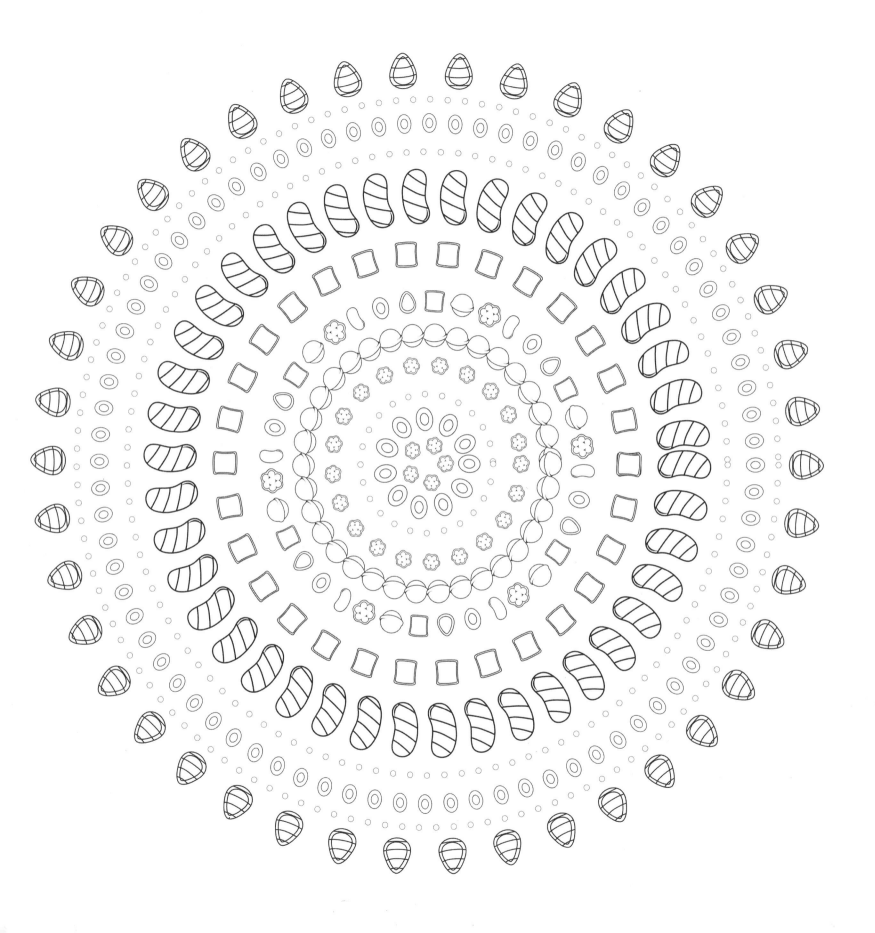

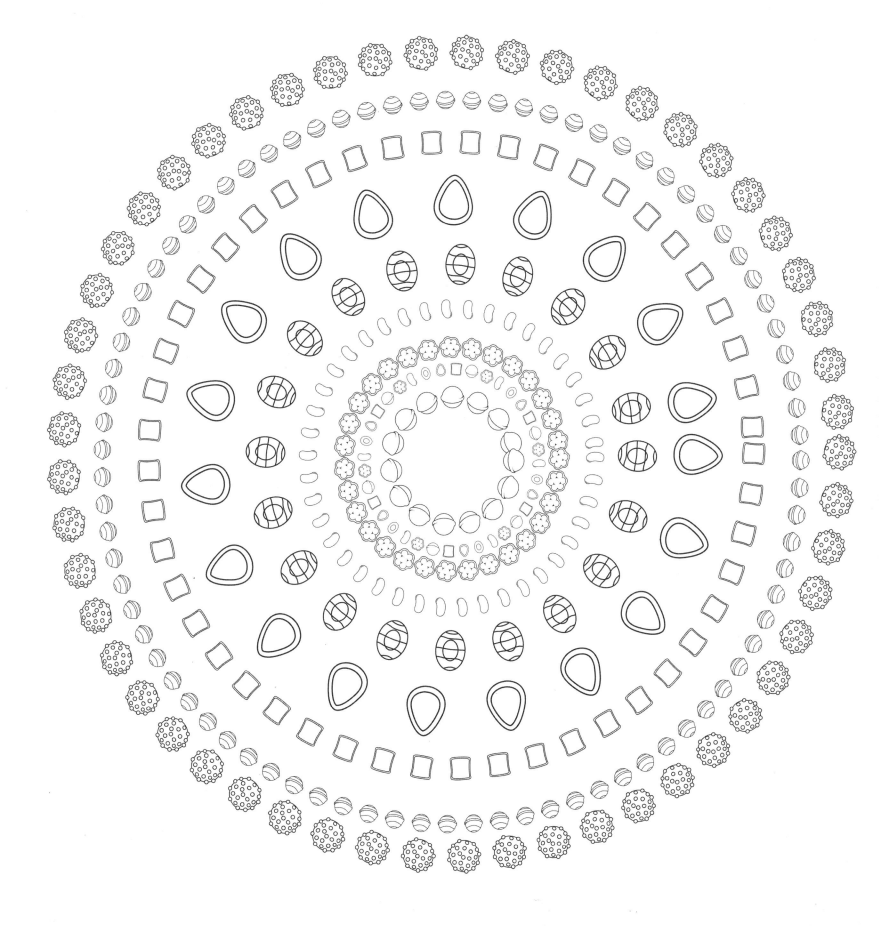

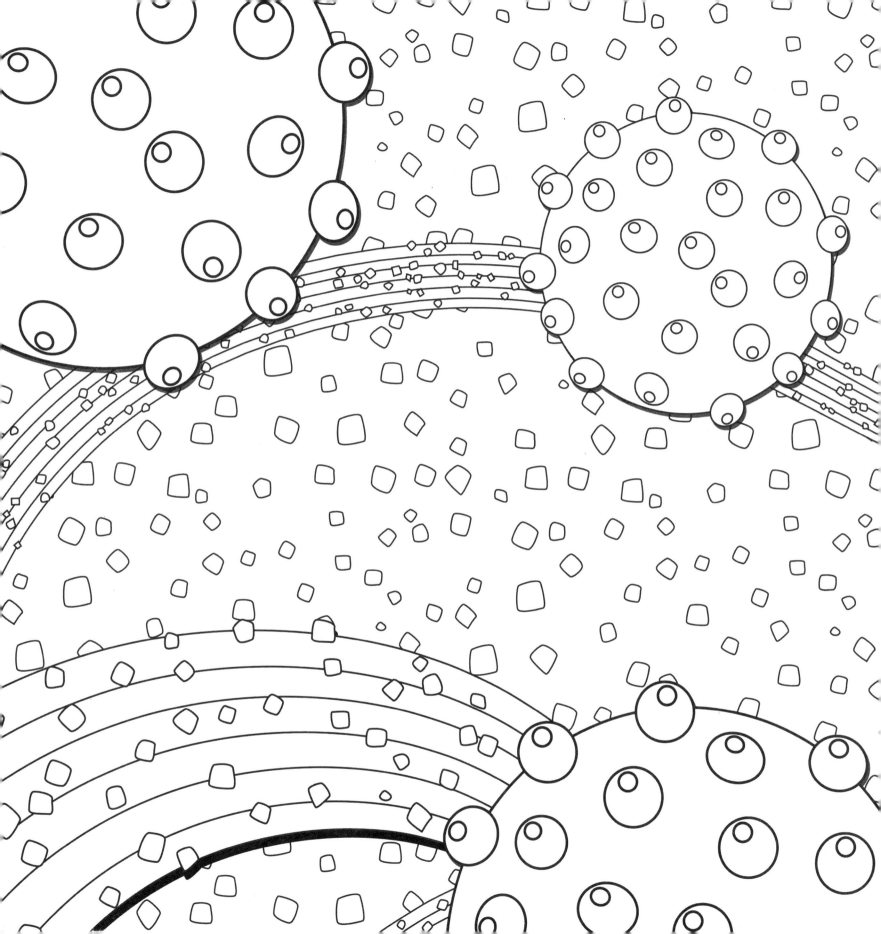

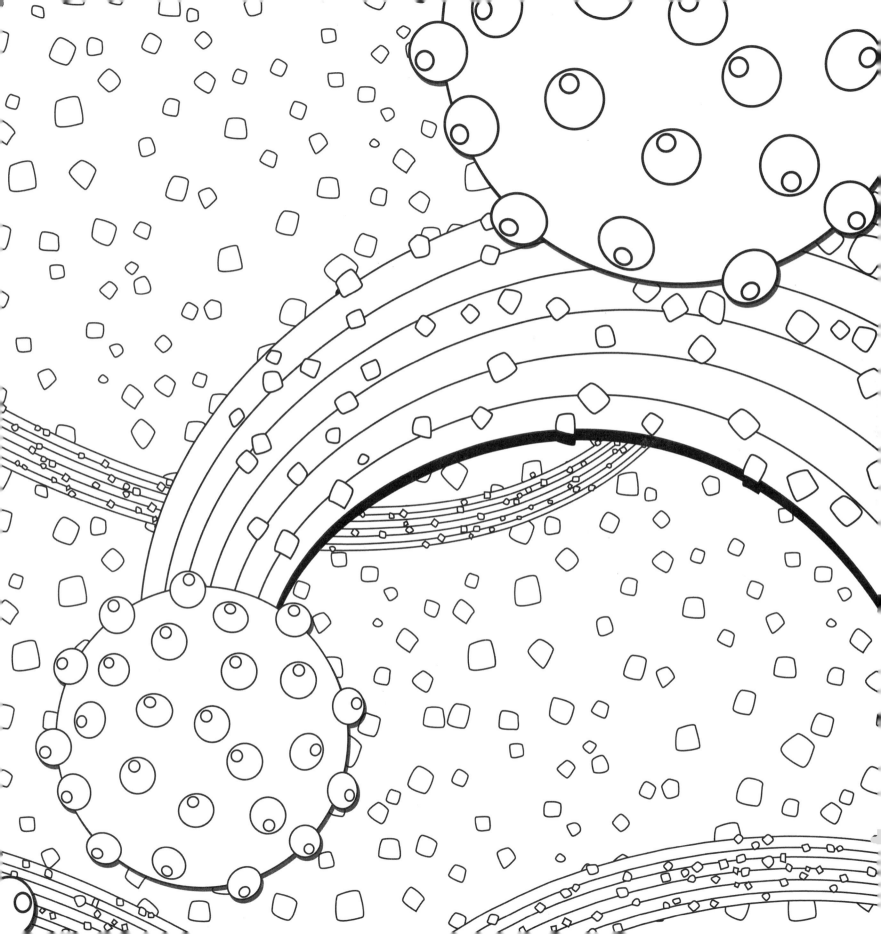

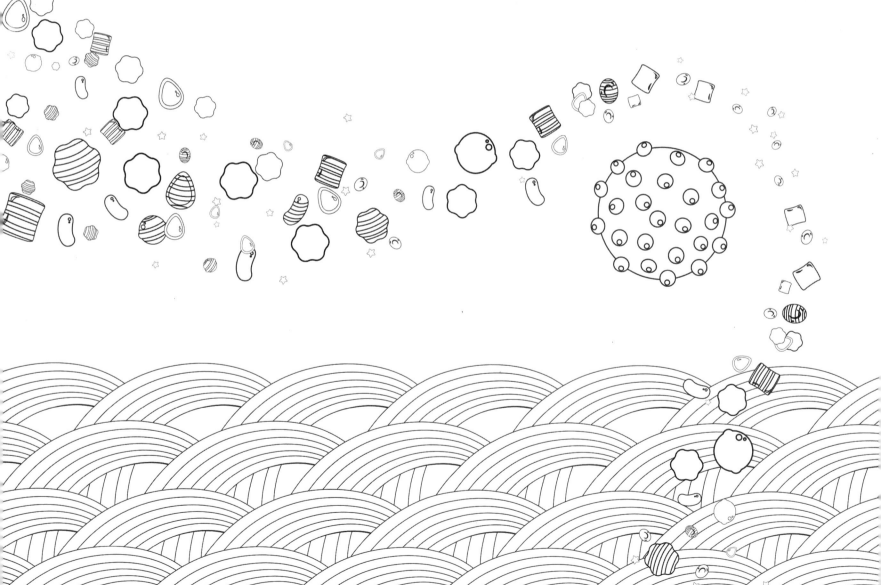

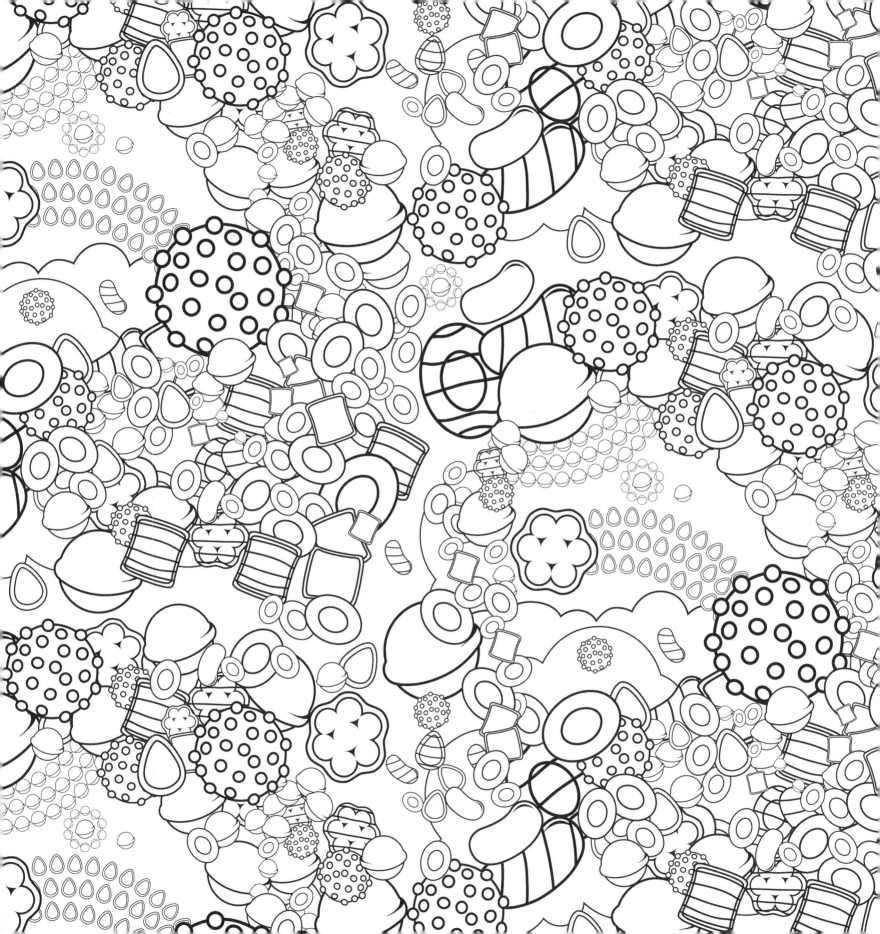

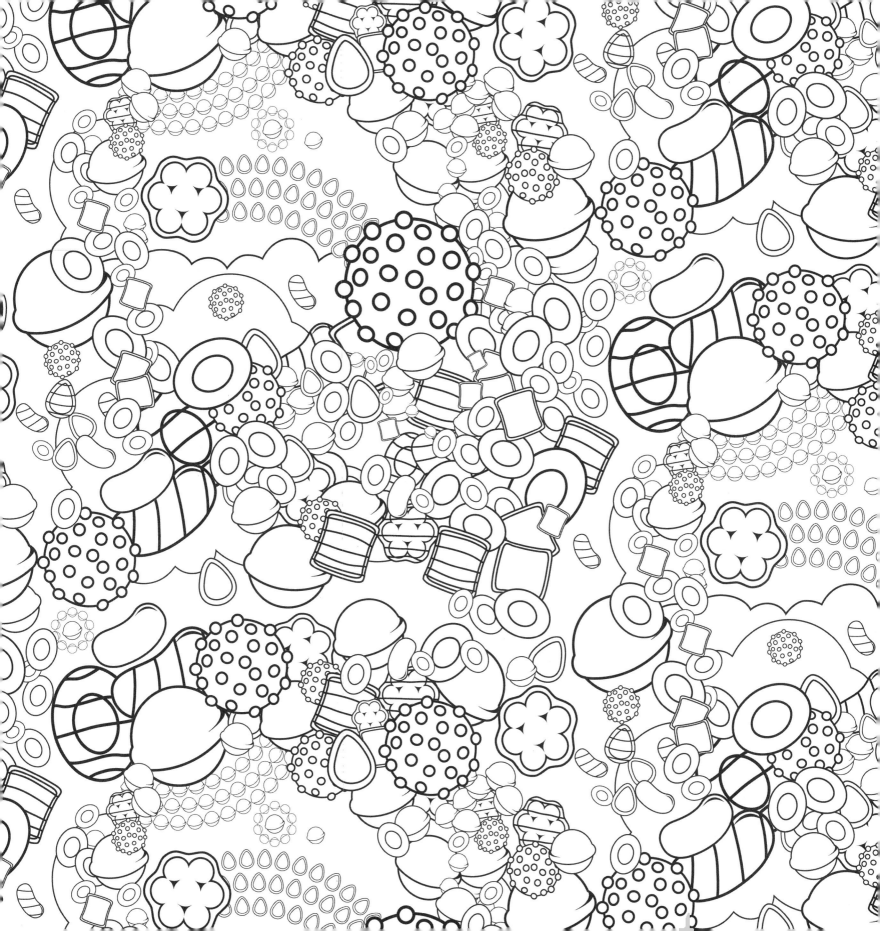

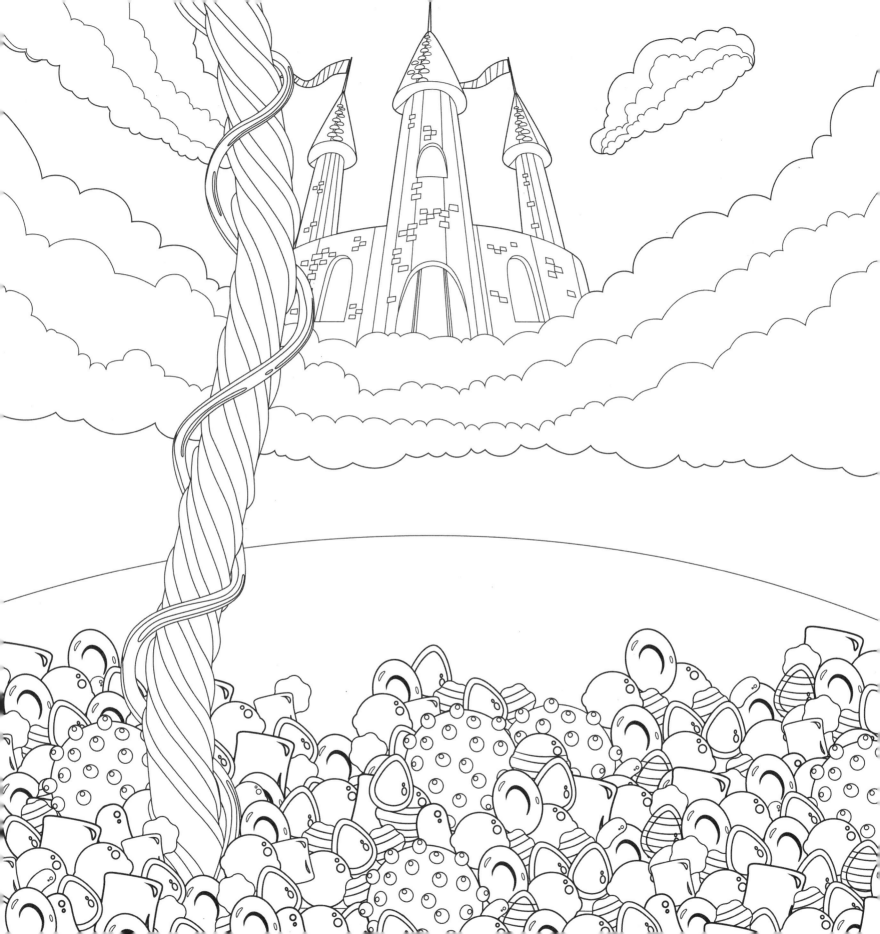

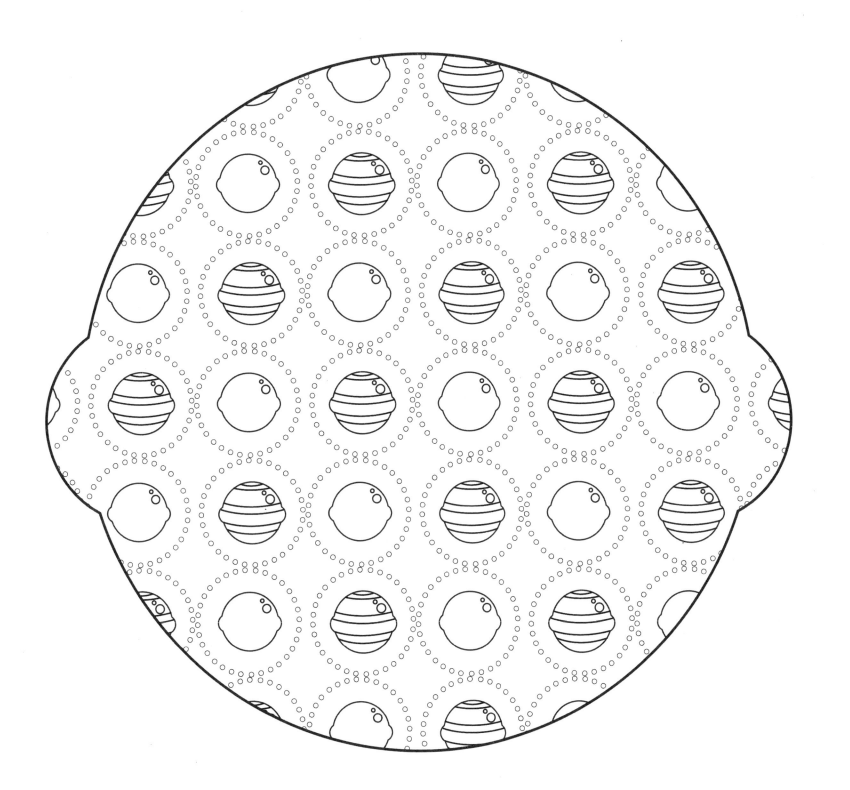

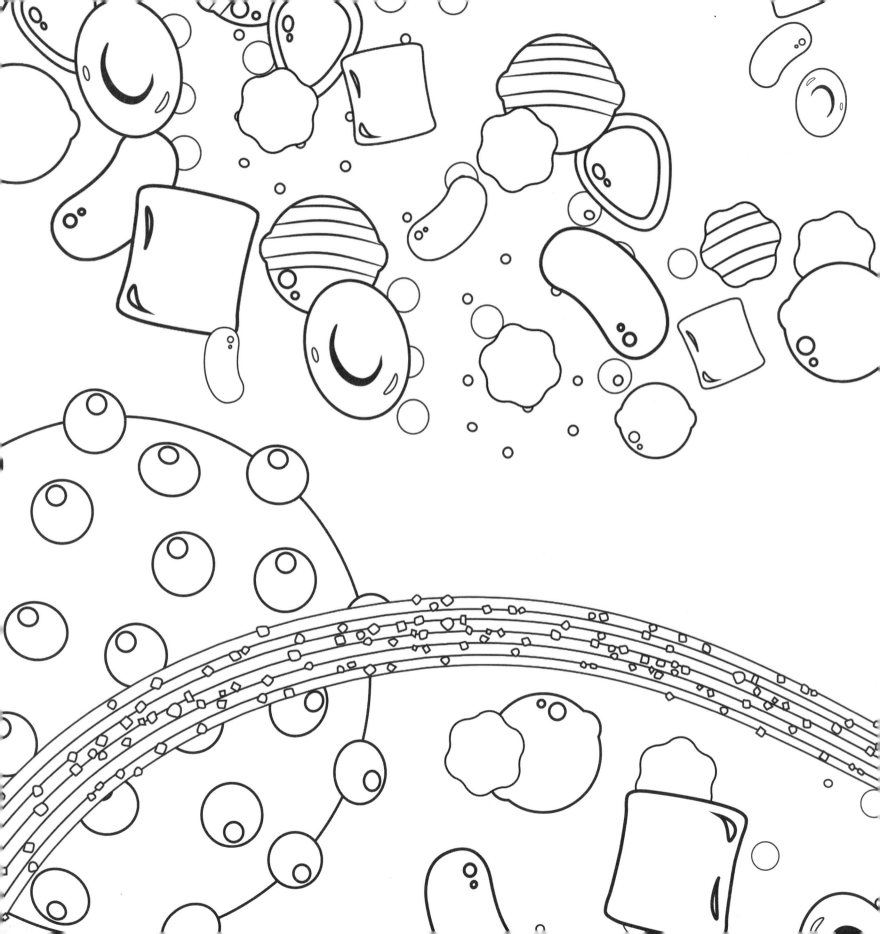

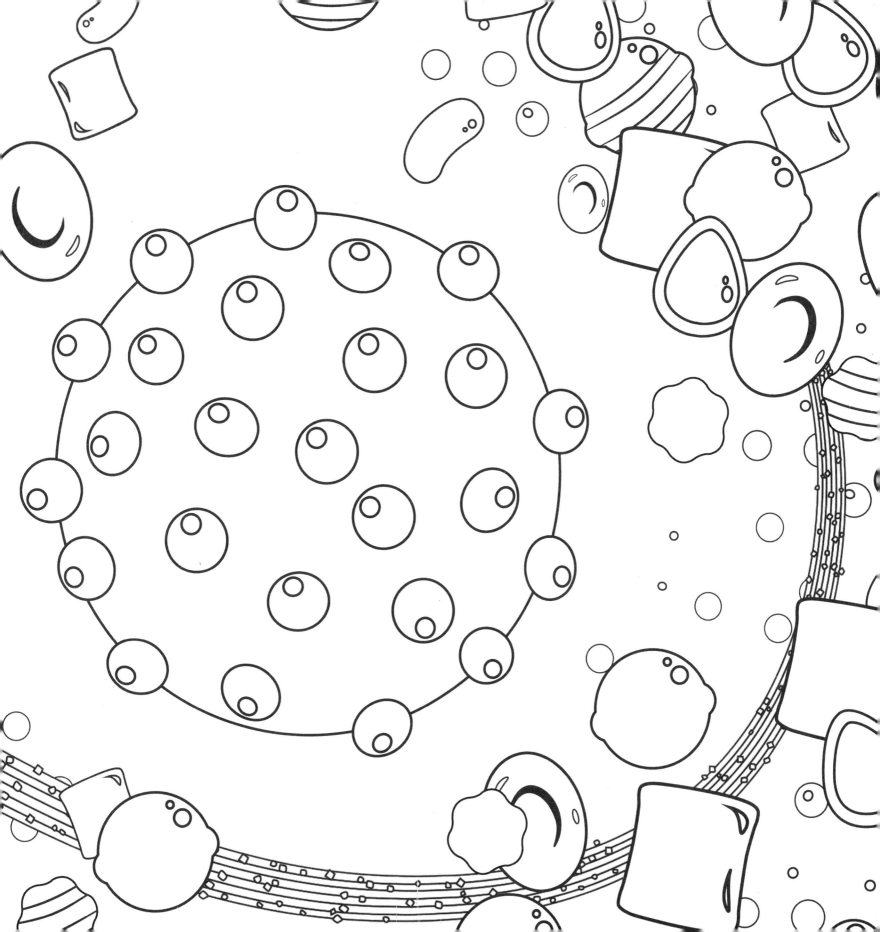

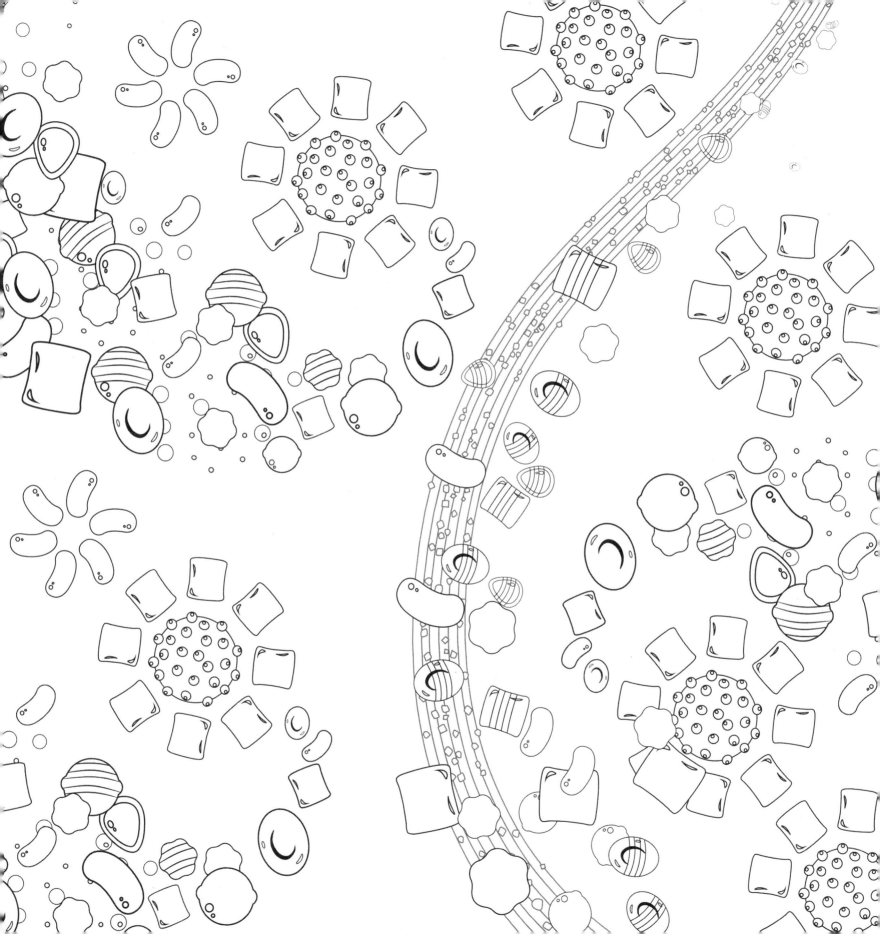

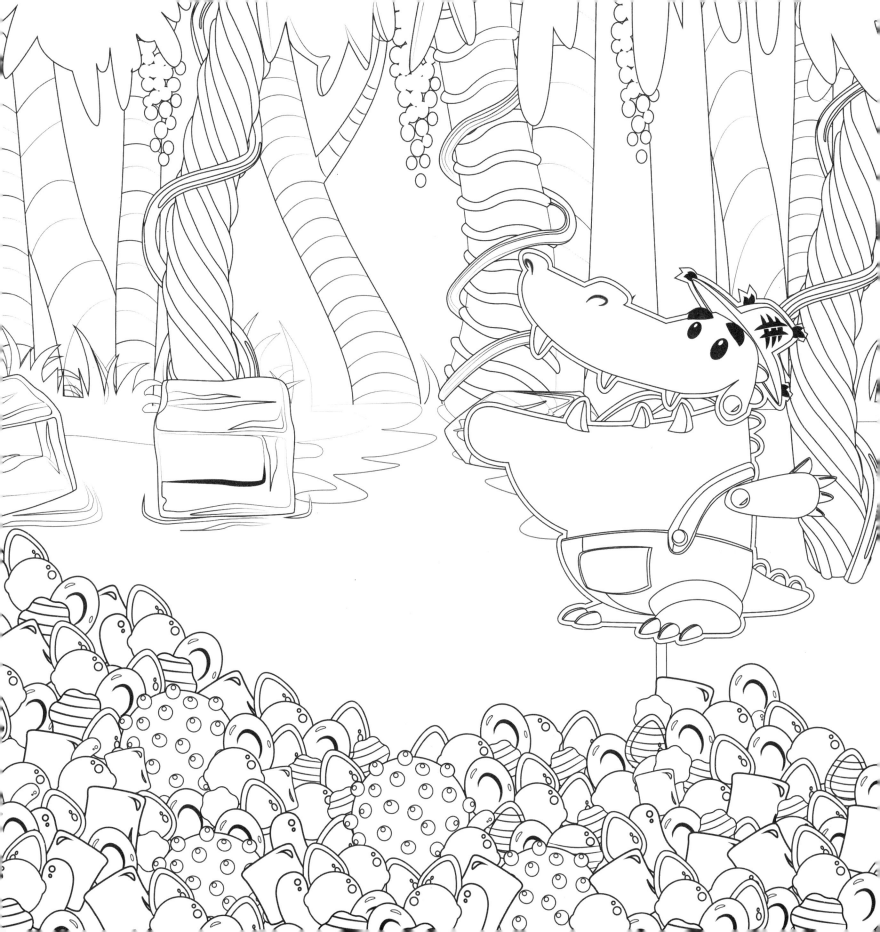

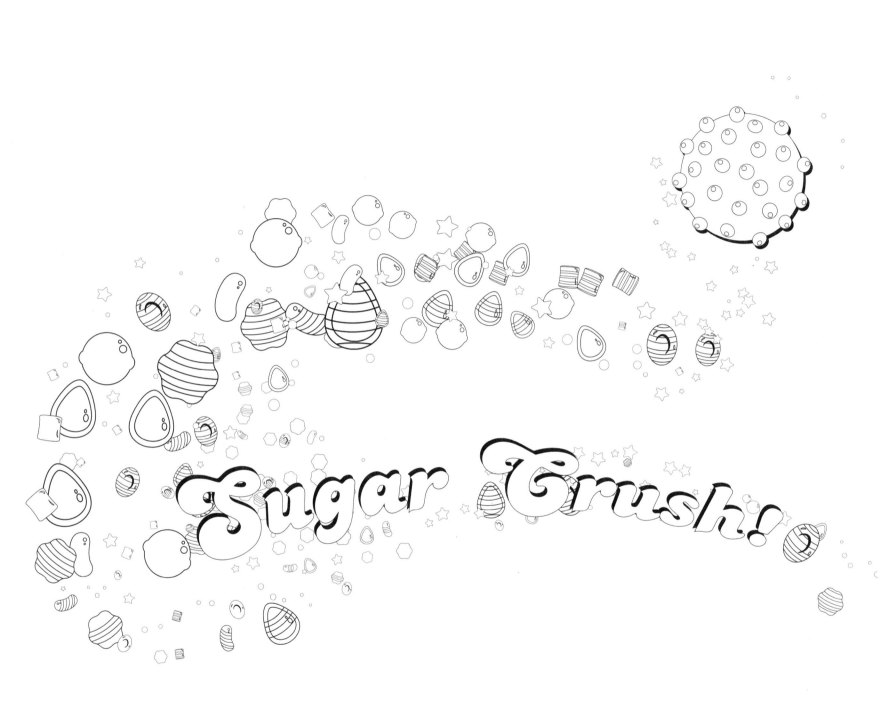

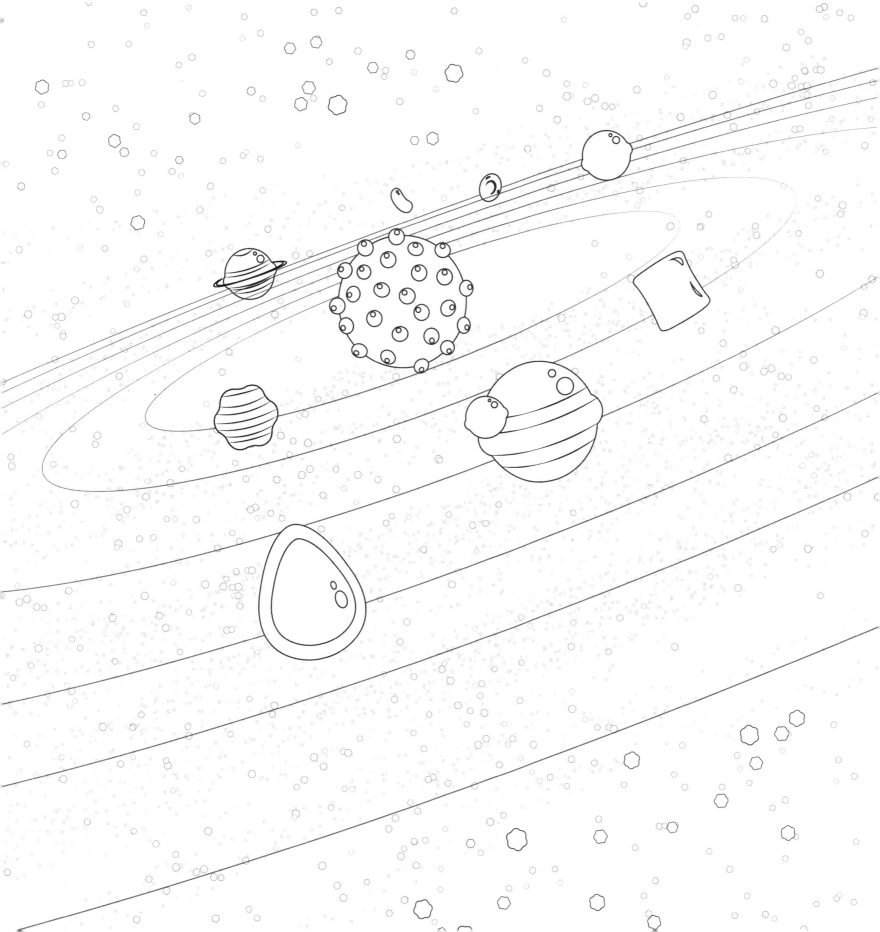

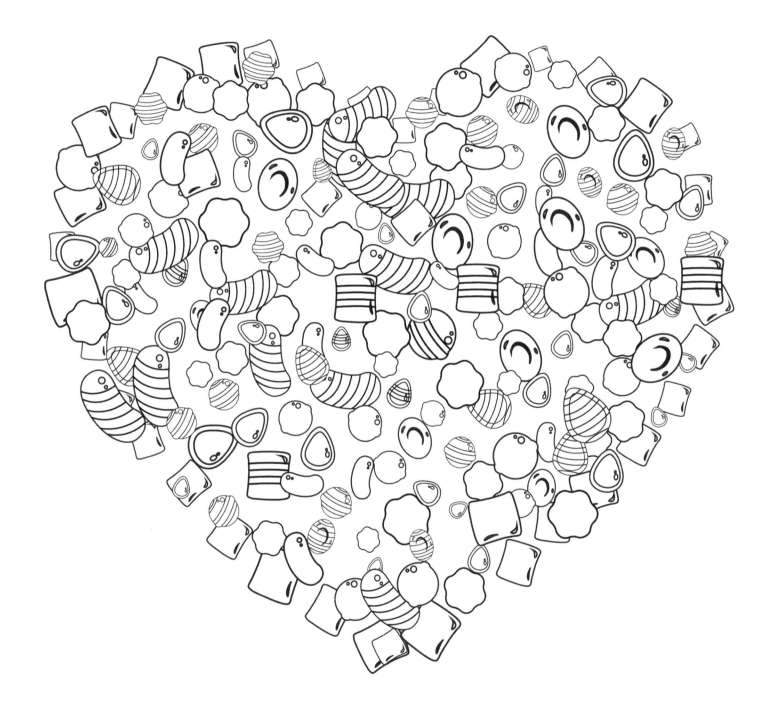

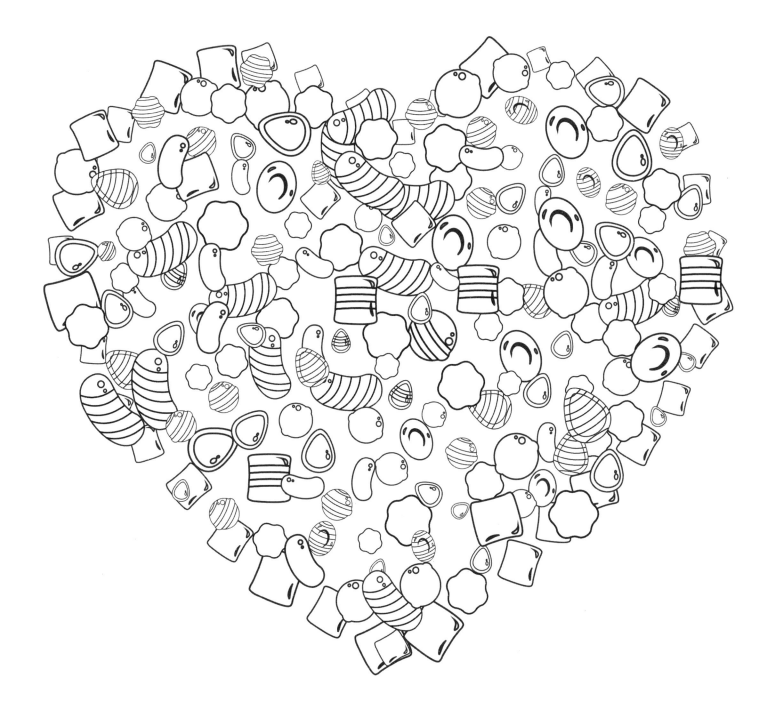

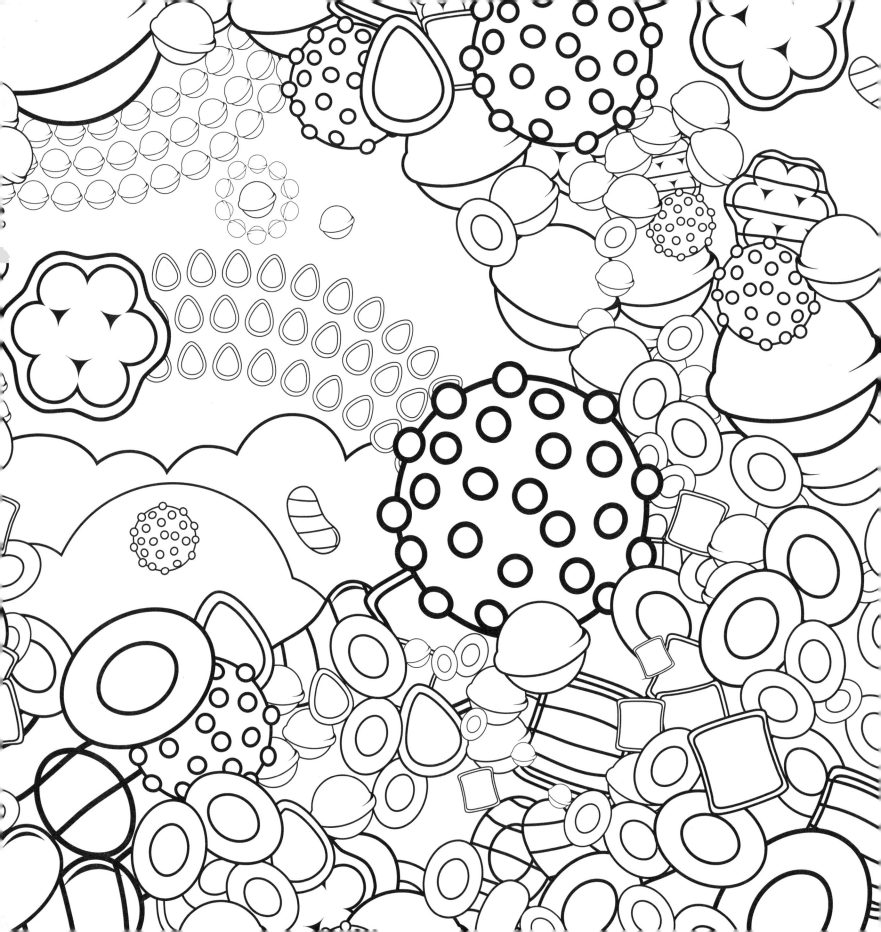

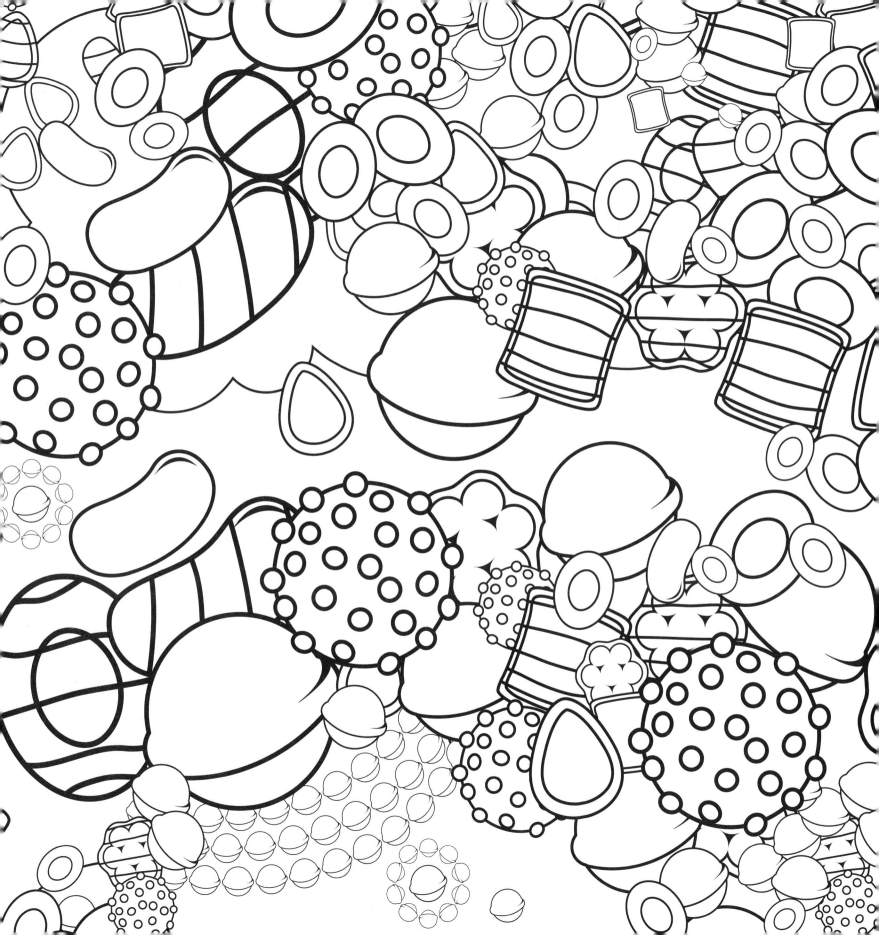

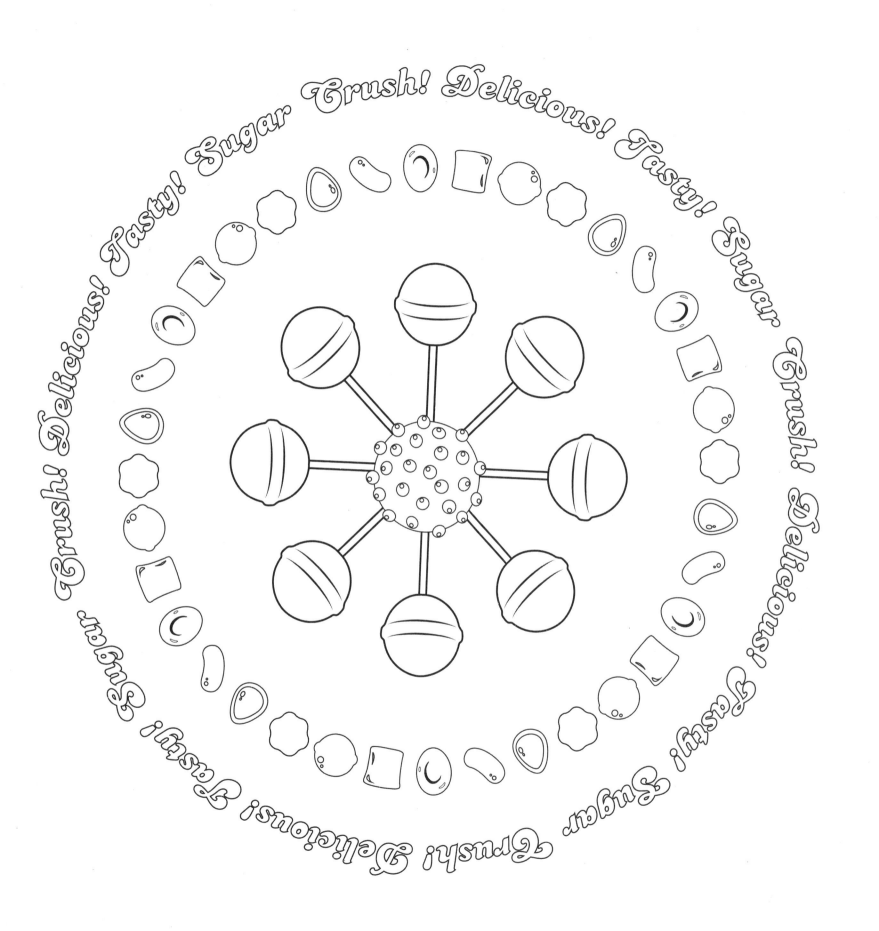

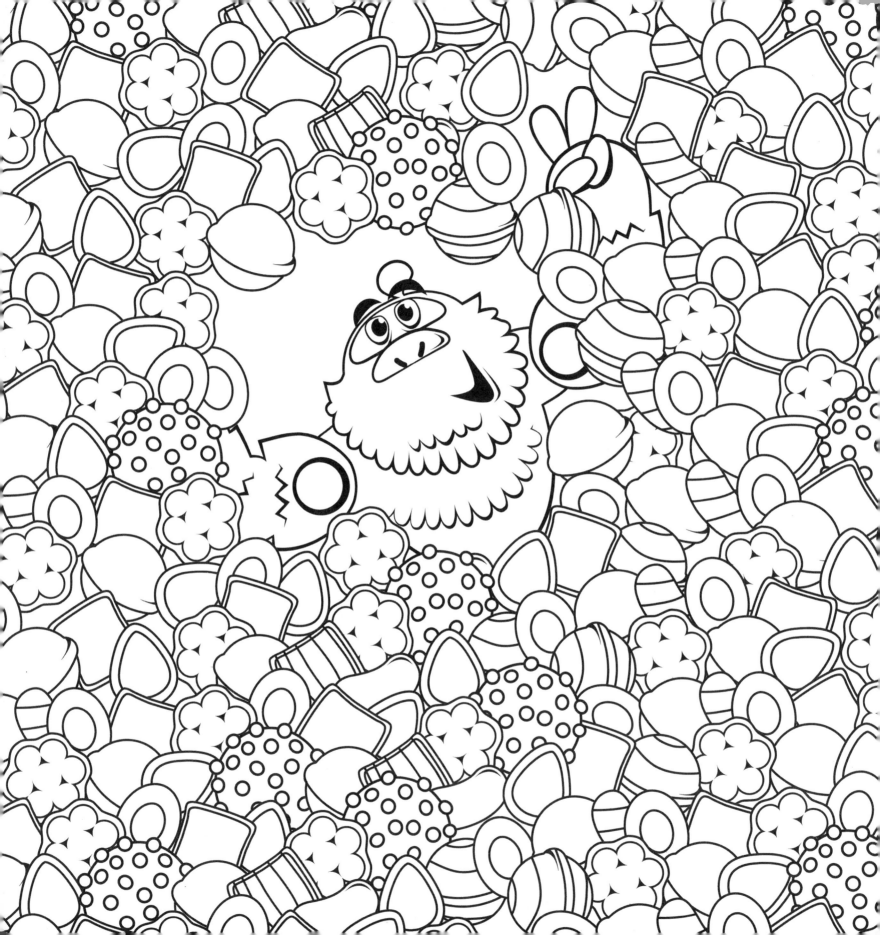

Make up your own
Candylicious designs!

Delicious!

Candy!